The Museum of Modern Art Book of Cartoons

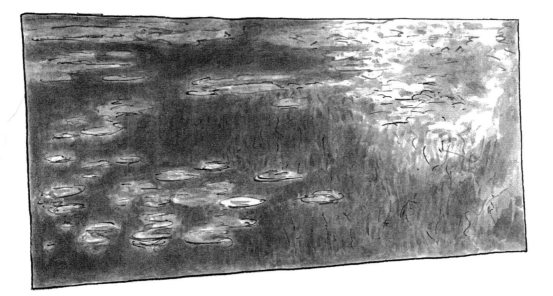

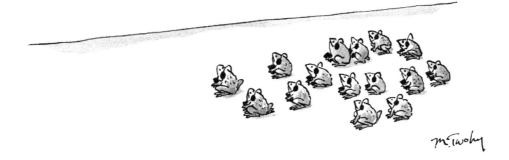

Featuring cartoons from THE NEW YORKER

Published by The Museum of Modern Art
11 W. 53 Street, New York, New York 10019

Distributed in the United States and Canada by D.A.P./Distributed Art Publishers, Inc., New York
Distributed outside the United States and Canada by Thames & Hudson Ltd, London

Library of Congress Control Number: 2007934024
ISBN: 978-0-87070-744-5

To purchase Custom Cartoon Books, framed prints of cartoons and covers, or to license
cartoons for use in periodicals, Web sites, or other media, please contact The Cartoon Bank,
a *New Yorker Magazine* Company, Tel: 800-897-8666, or (914) 478-5527, Fax: (914) 478-5604,
E-mail: custombooks@cartoonbank.com, Web: www.cartoonbank.com.

First edition published 2006
Reprint edition published 2007

The Museum of Modern Art Book of Cartoons

Featuring cartoons from THE NEW YORKER

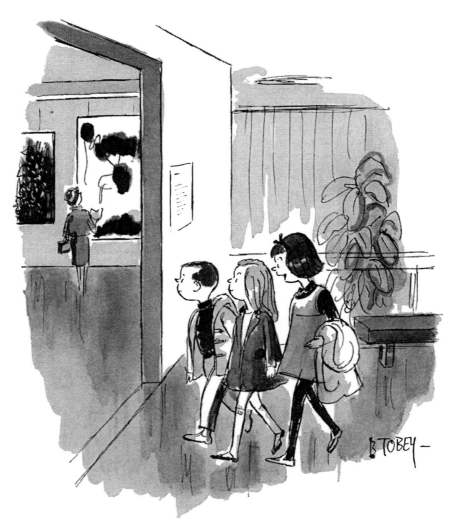

"I know more about art than you do, so I'll tell you what to like."

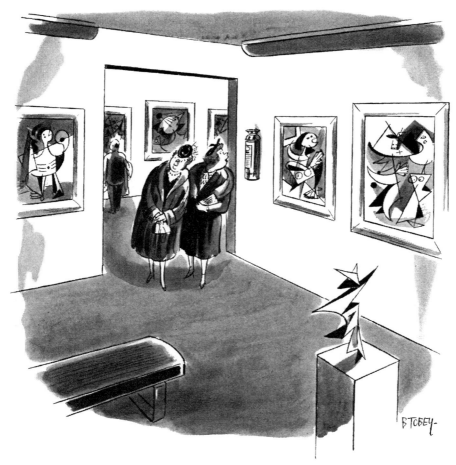

"We've already done this room. I remember that fire extinguisher."

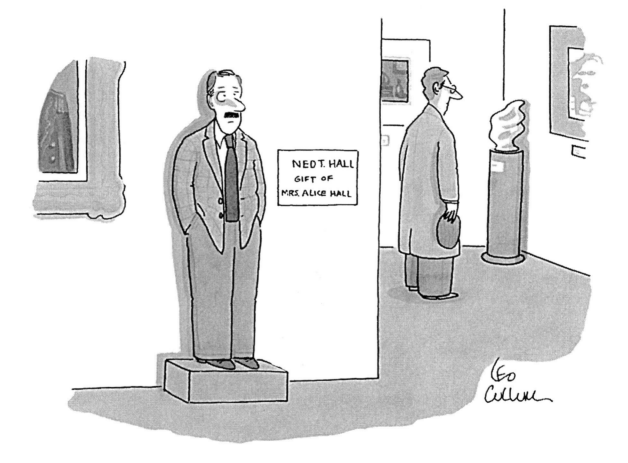

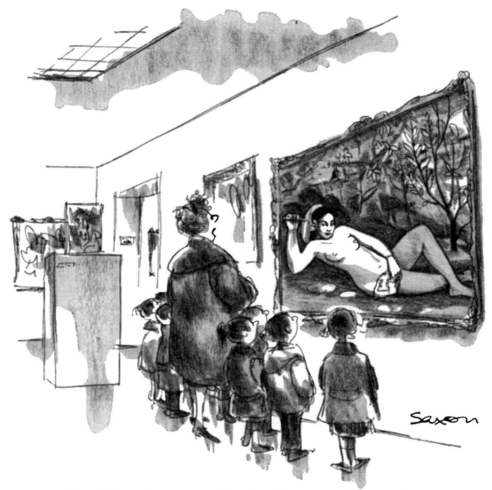

"Paul Gauguin was a restless, brooding man who was always searching for that indefinable something."

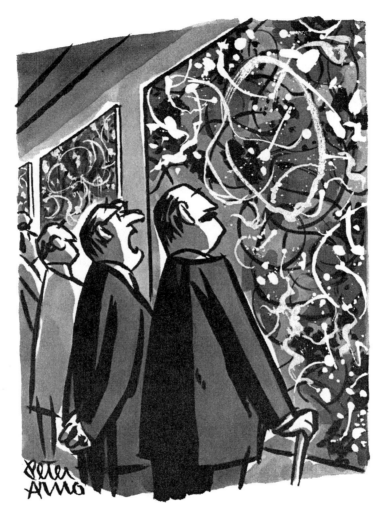

"*His spatter is masterful, but his dribbles lack conviction.*"

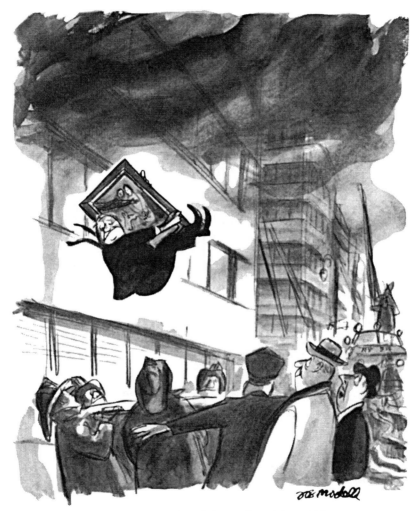

"I believe you're right. It *is* a Chagall."

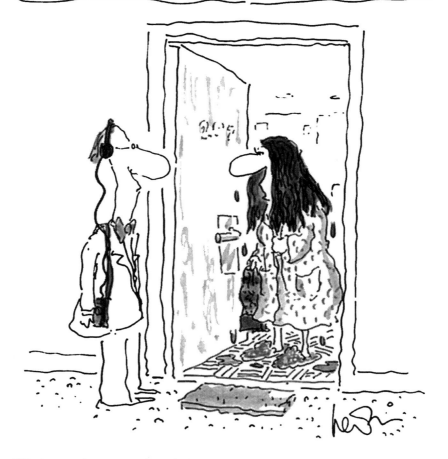

"You're on the wrong floor. The Museum of Modern Art is downstairs."

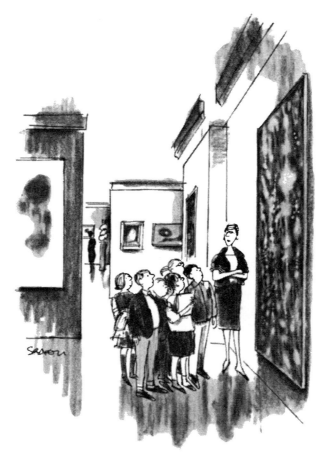

"Now perhaps Edwin will tell us why he thinks this painter is 'cool.'"

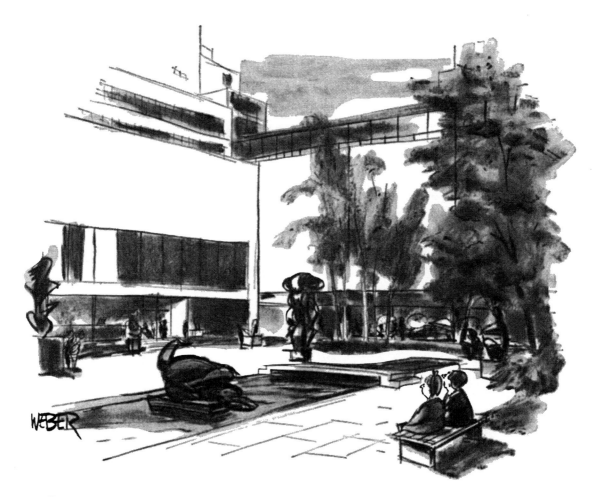

"I'll tell you what's wrong with The Museum of Modern Art. The sandwiches are skimpy."

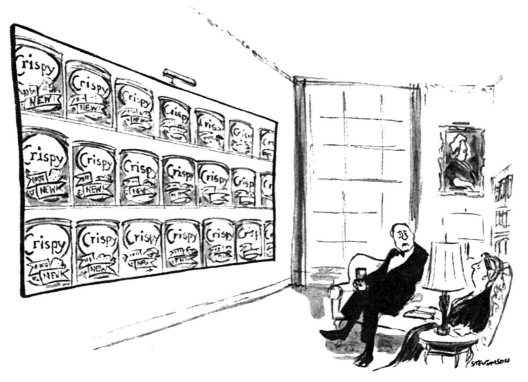

"I'm sorry to say it, dear, but I'm afraid I miss my Monet."

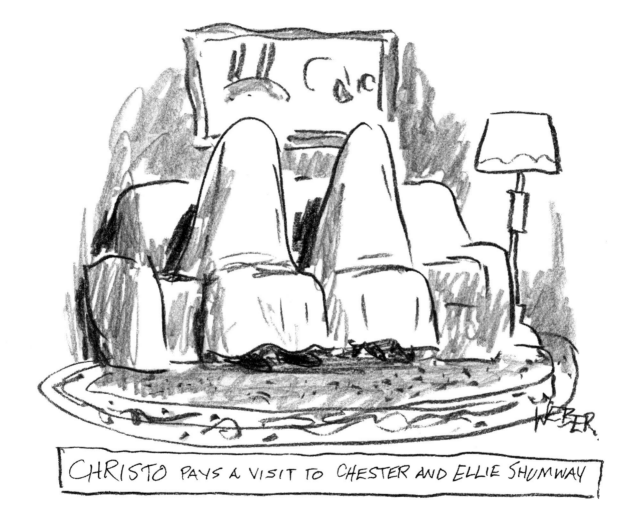

CHRISTO PAYS A VISIT TO CHESTER AND ELLIE SHUMWAY

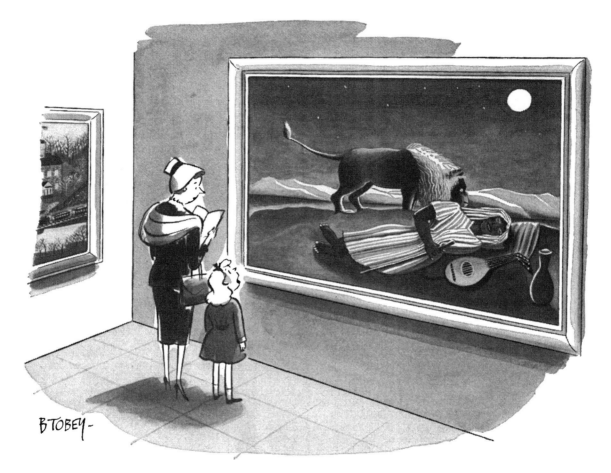

"Then what happened?"

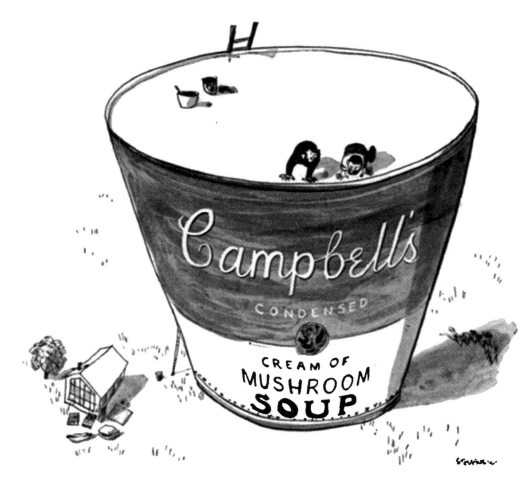

"You must be terribly proud. It's the finest thing you've done."

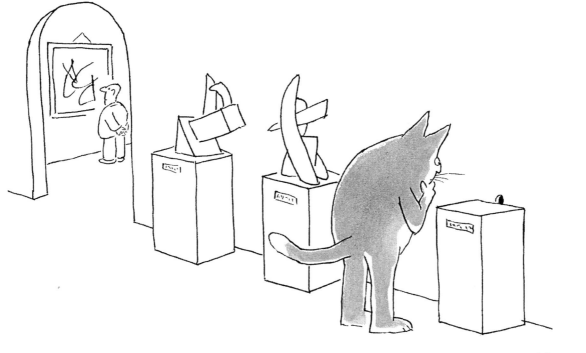

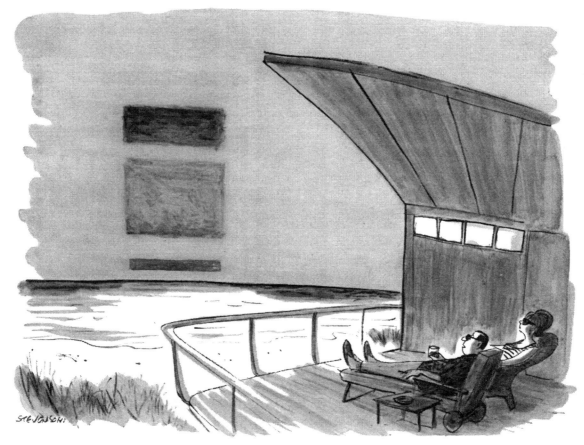

"Now, there's a nice contemporary sunset!"

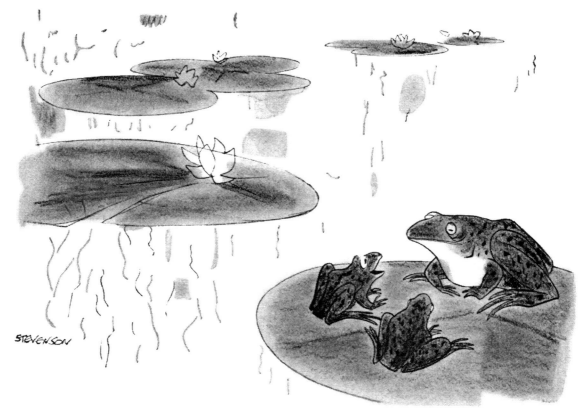

"Tell us again about Monet, Grandpa."

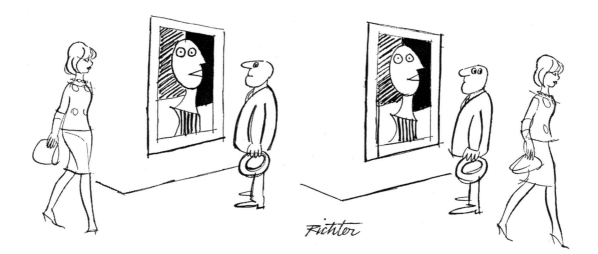

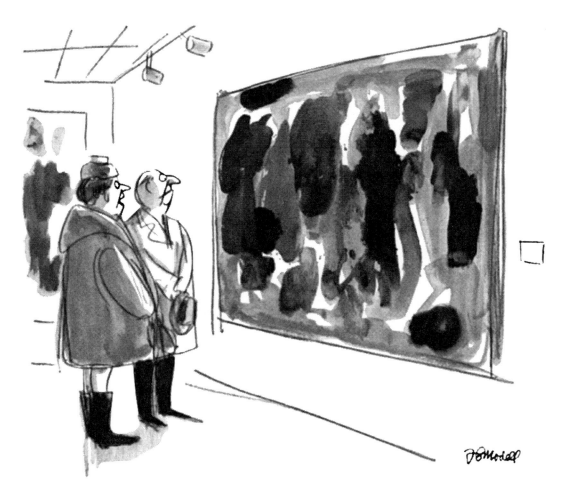

"I did not say I liked it. I said I didn't mind it."

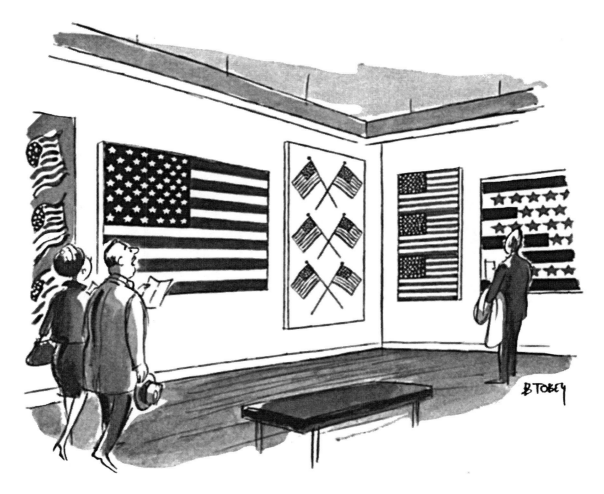

"He's certainly on safe ground. Who'd dare not to like them?"

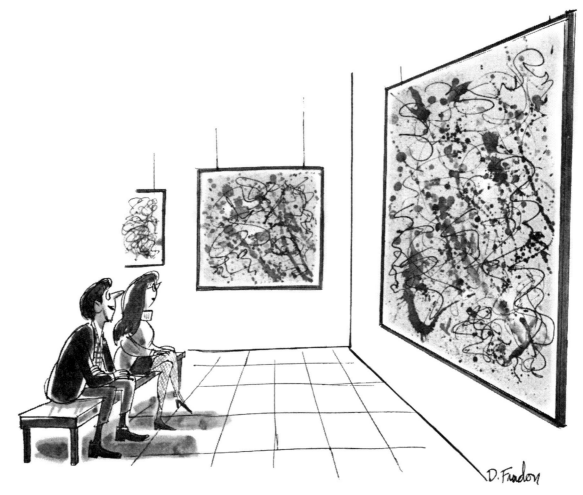

"*Those old guys really had it!*"

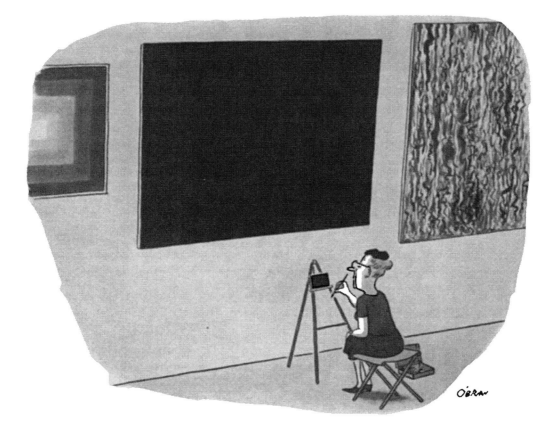

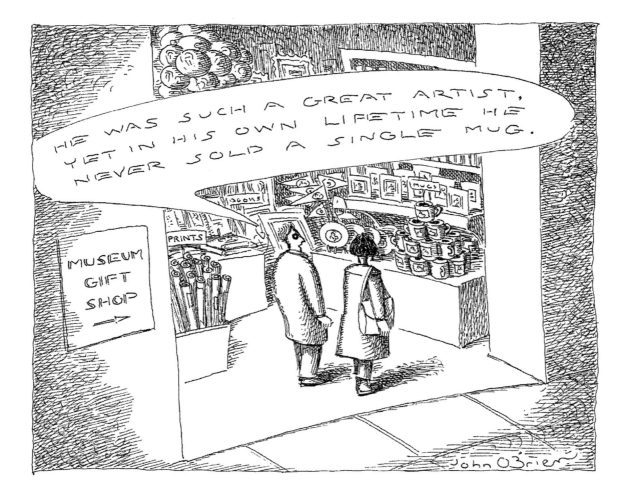

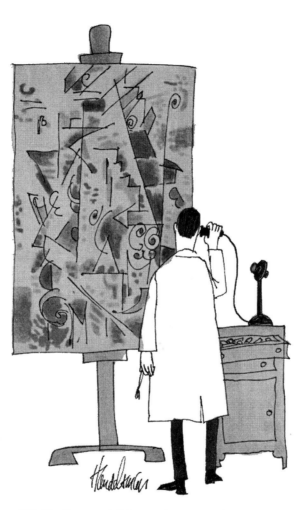

"Hello, Braque? Picasso here. Cubism is out."

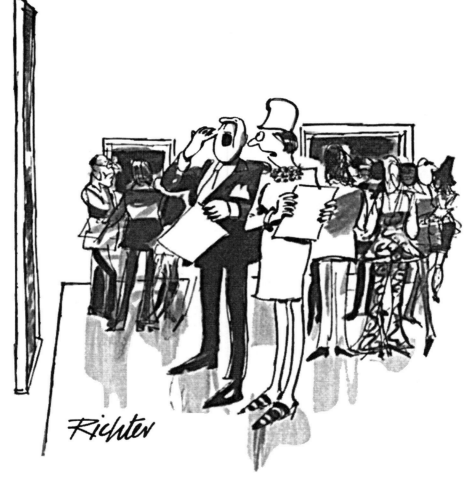

"*Please! Not at a major breakthrough!*"

"*We haven't, of course, but I have the strangest feeling that we've been here before.*"

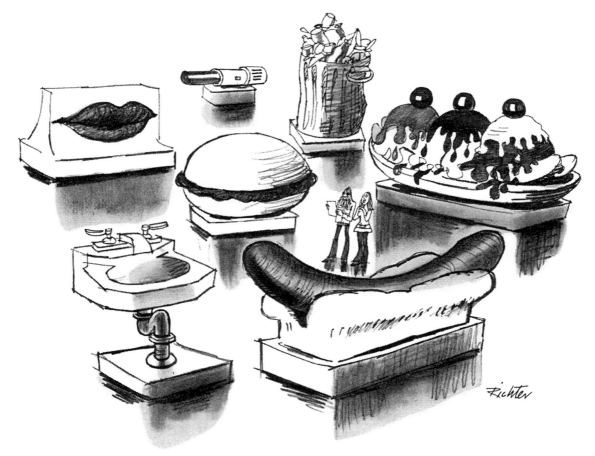

"Wow! You mean they got all this in exchange for just one van Gogh?"

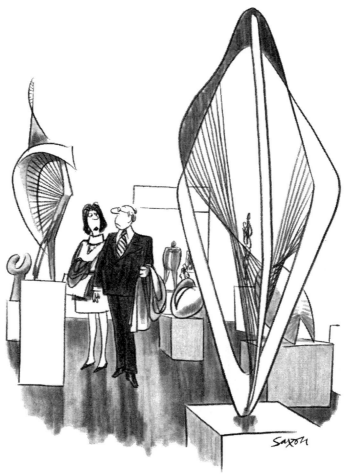

"Do you mind? I'm forming an opinion!"

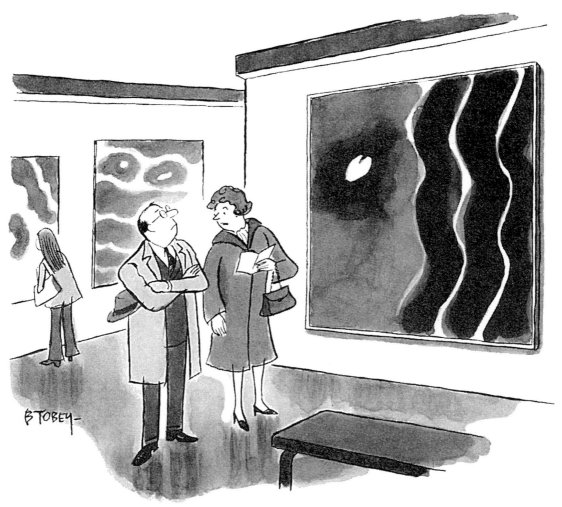

"*Of course you don't understand it. He's an artists' artist.*"

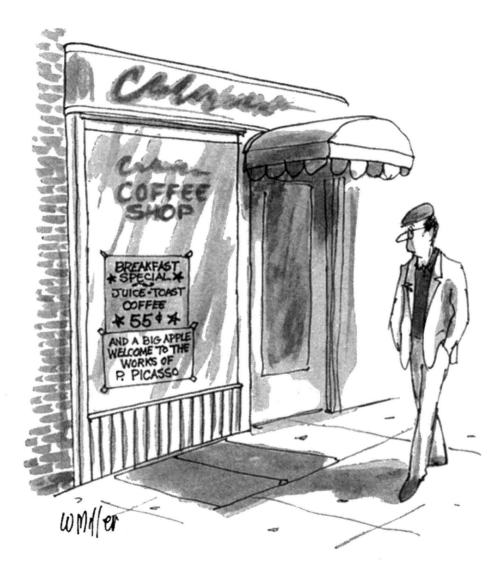

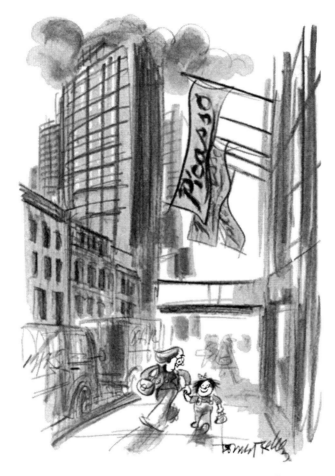

"Yes, dear—the same name as our cat."

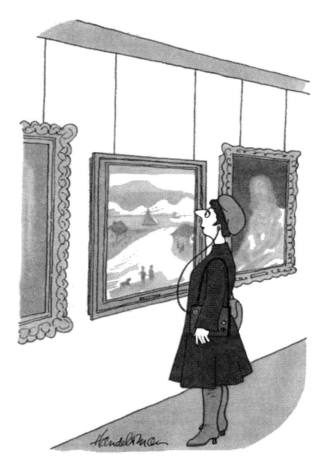

"We like this picture very much. We don't know why. We just do."

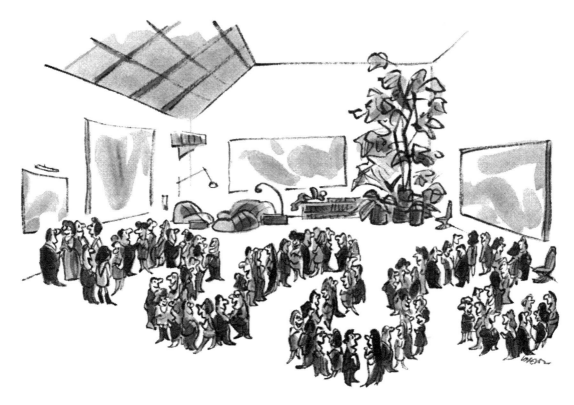

"I guess what it means is we're all members of the stand-in-line generation."

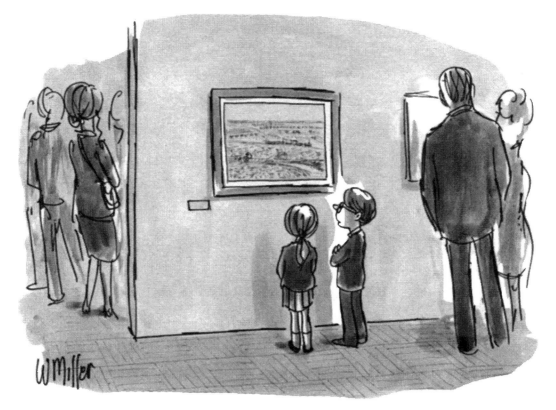

"Van Gogh was a good painter, but he couldn't draw trains."

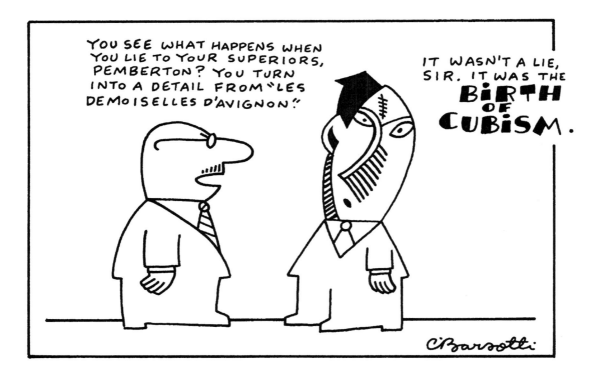

FROM THE MUSEUM OF MODERN ART'S
COLLECTION OF AMERICAN MIXOLOGY...

...THE MIES MARTINI

"No, wait. I always get this mixed up. The Manet was
five point nine. The Monet was three flat."

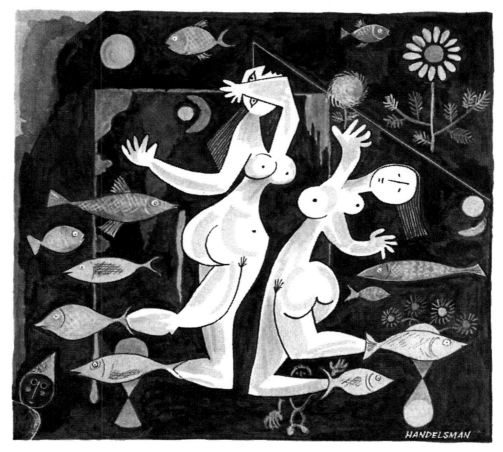

Two Picassos with Feet of Klee

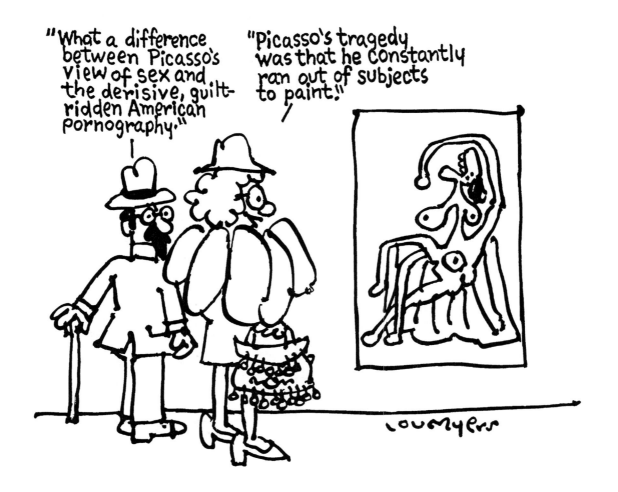

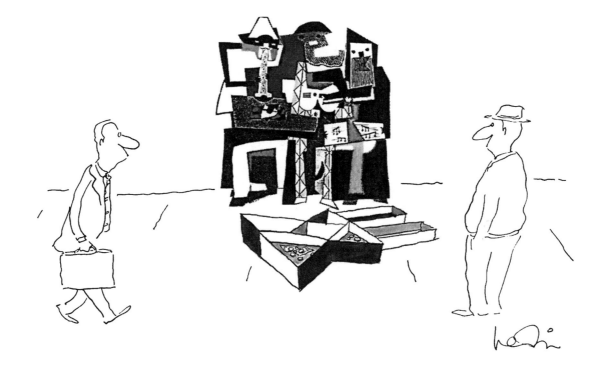

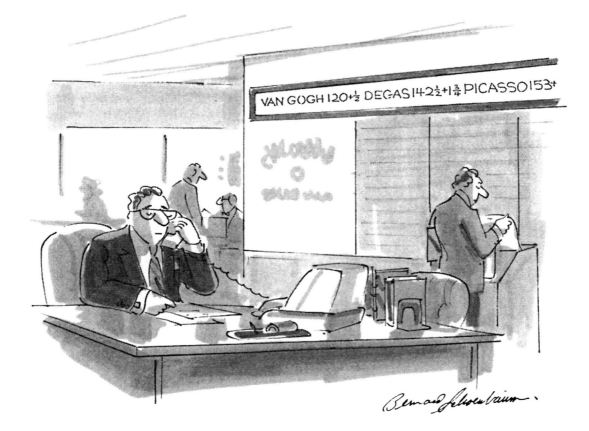

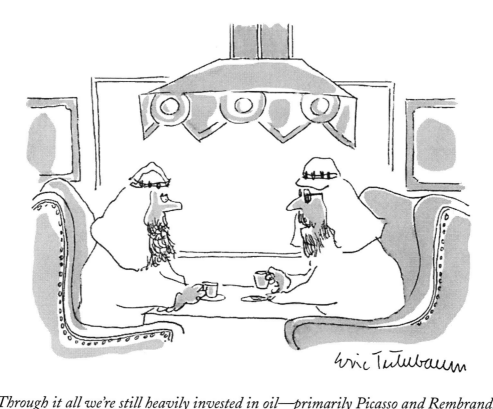

"Through it all we're still heavily invested in oil—primarily Picasso and Rembrandt."

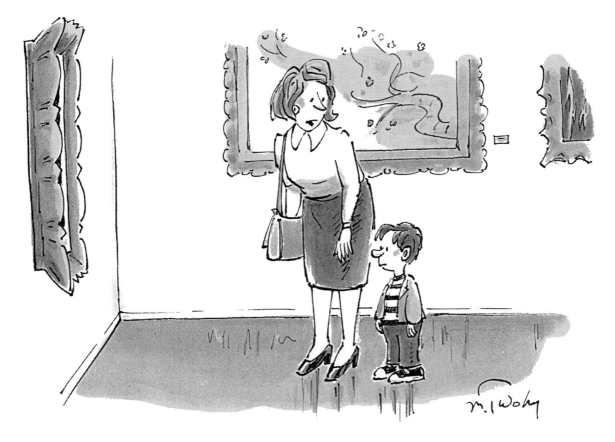

"Instead of 'It sucks' you could say, 'It doesn't speak to me.'"

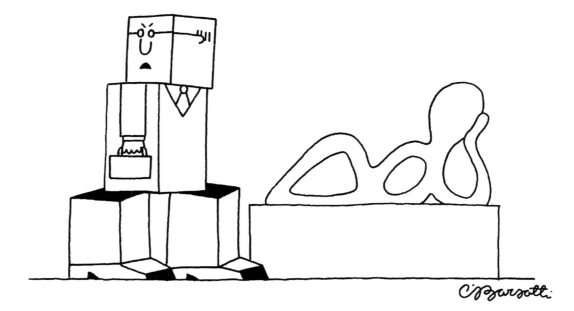

"Miss Crutchfield, have you gone mad?"

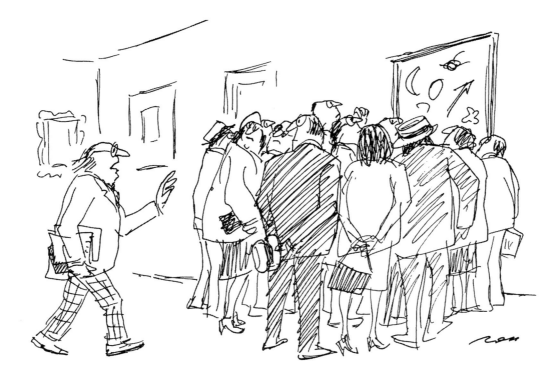

"Let me through! I'm a critic."

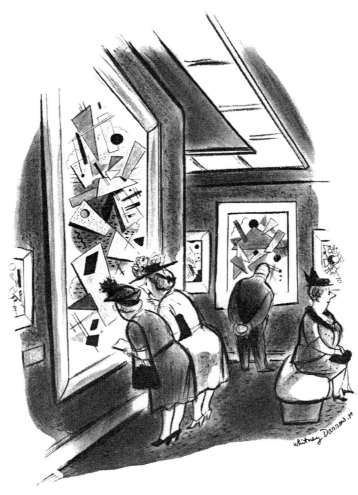

"Oh, look—I think I see a little bunny."

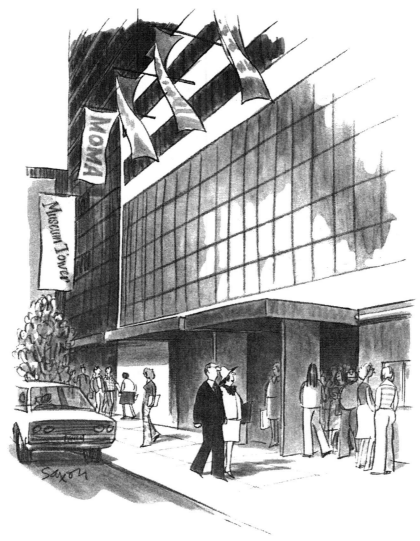

"Why don't we take a look? It's twice as big, but
you can leave when you've had enough."

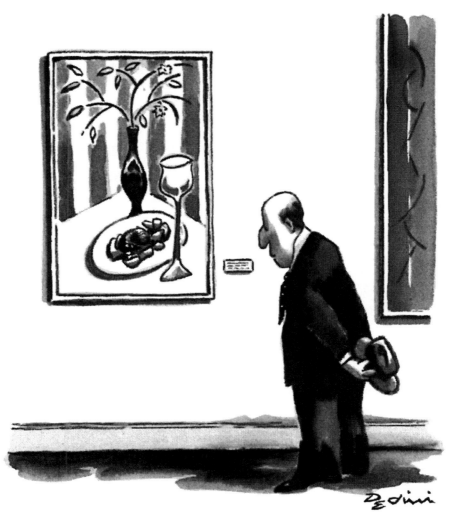

"Still–Life of New Mexican Grilled Quail with Cilantro and Fennel–Flecked Confit."

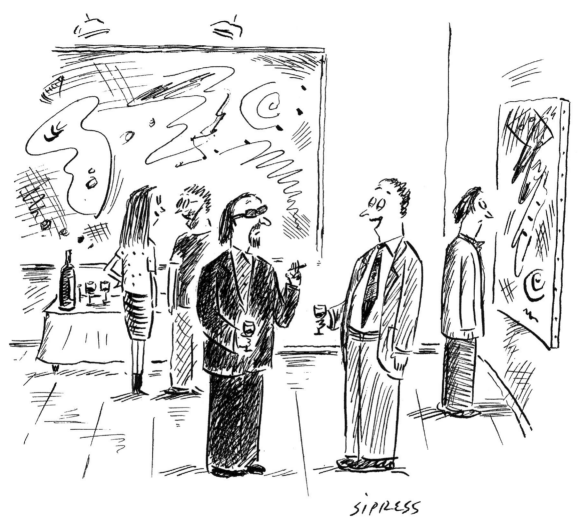

"I live in the Brooklyn arrondissement."

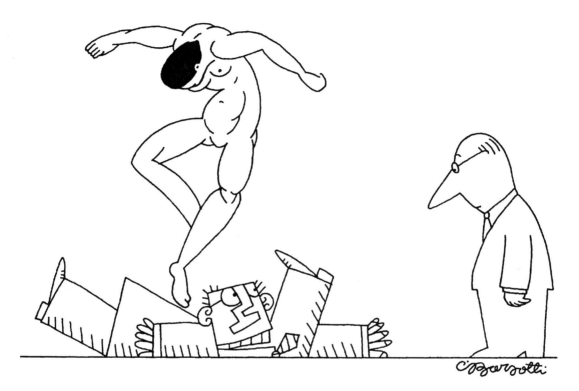

"I don't know a damn thing about art, but my back hasn't felt this good in years."

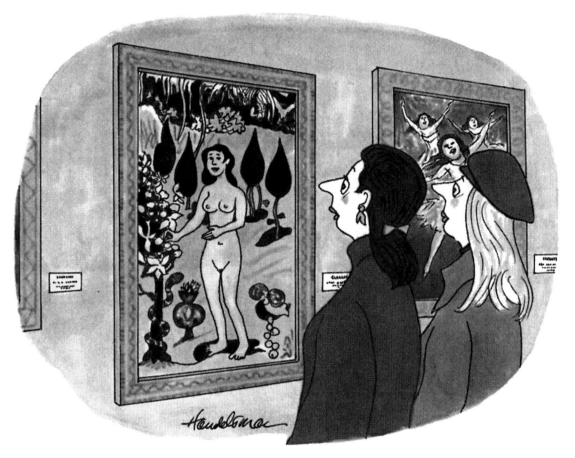

"He begged his wife and kids to join him in Tahiti,
but he didn't mean a word of it, the bastard."

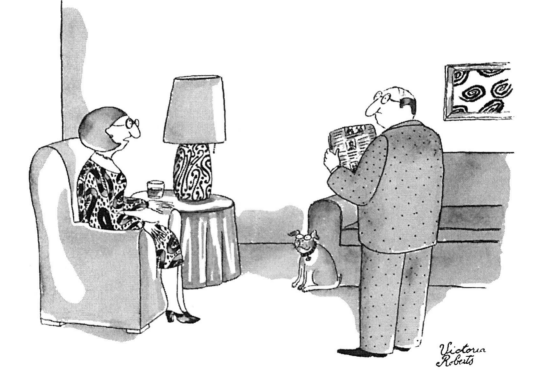

"You wanted to miss the Matisse show."

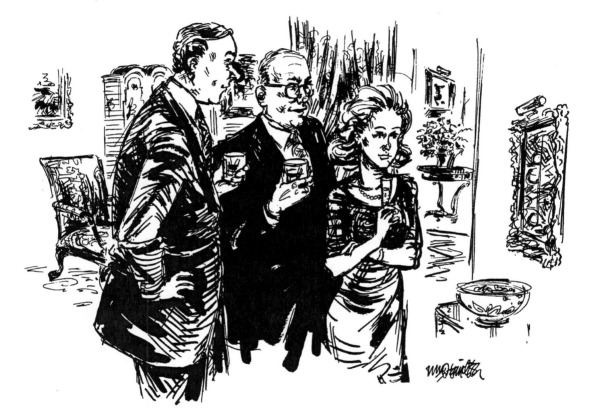

"Cézanne is as goofy as I like to get."

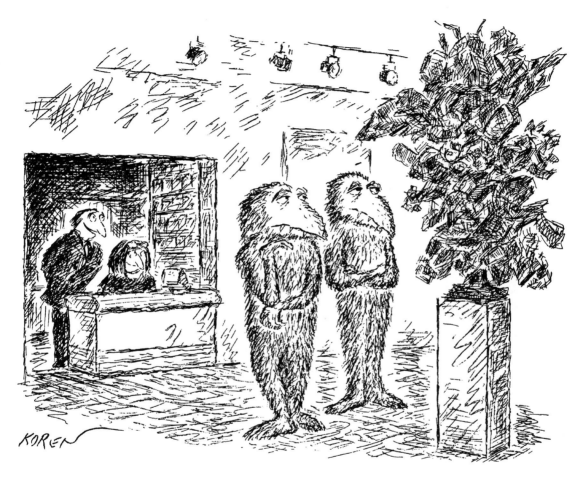

"*They have extraordinary taste.*"

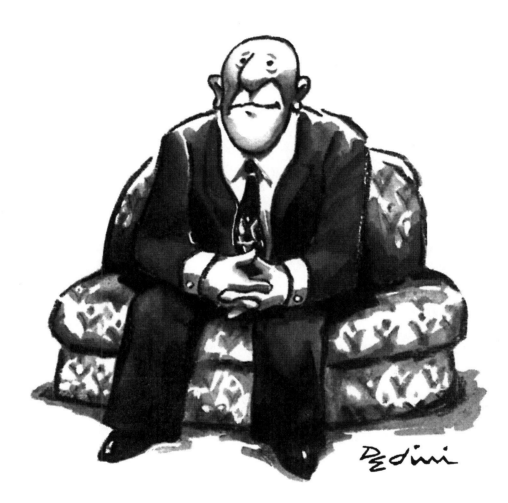

"*While he was in Paris, Warren knew Picasso,
Miró, Hemingway, Stravinsky, Cocteau, and Fitzgerald.
Nothing ever came of it.*"

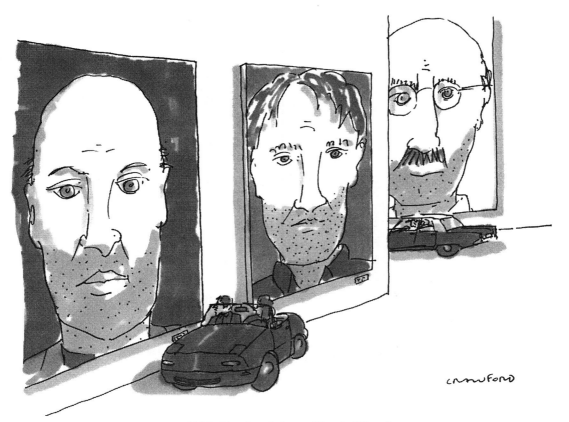

"He's big, but he's no Chuck Close."

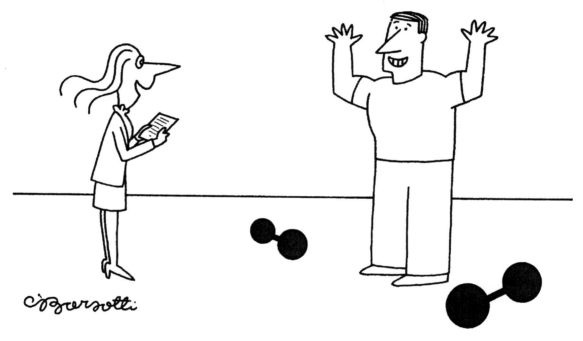

"It's from MoMA. You've been accepted for the permanent collection."

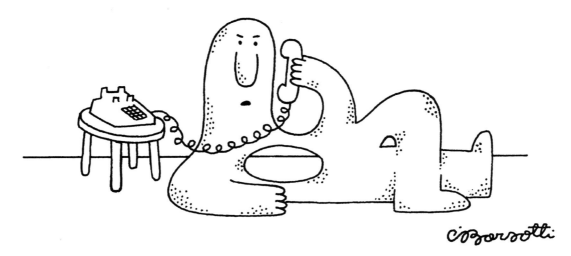

"Absolutely not. I don't give my provenance over the phone."

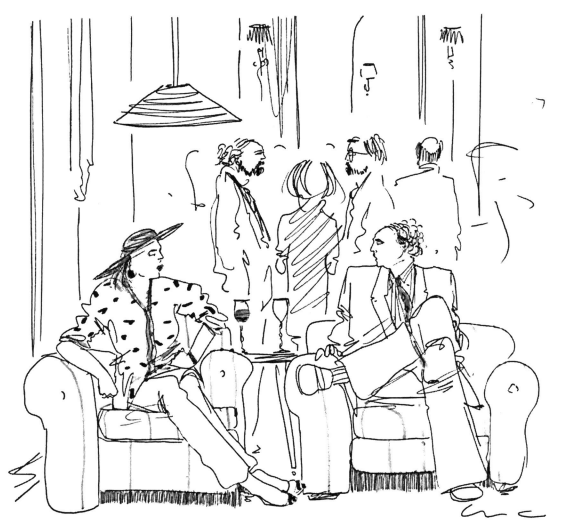

"Is it you or a Cindy Sherman version of yourself?"

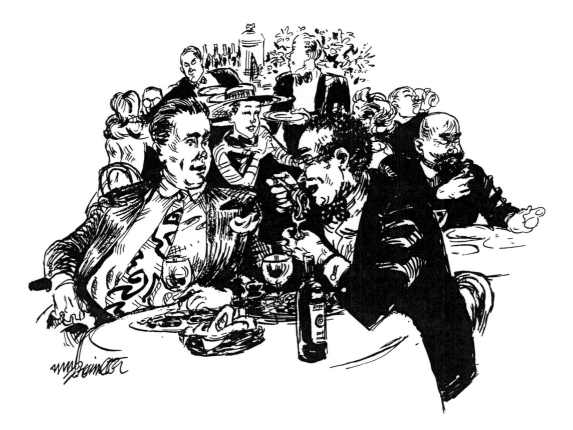

"Nonsense—I can sit on my Warhols twice as long as you can sit on yours."

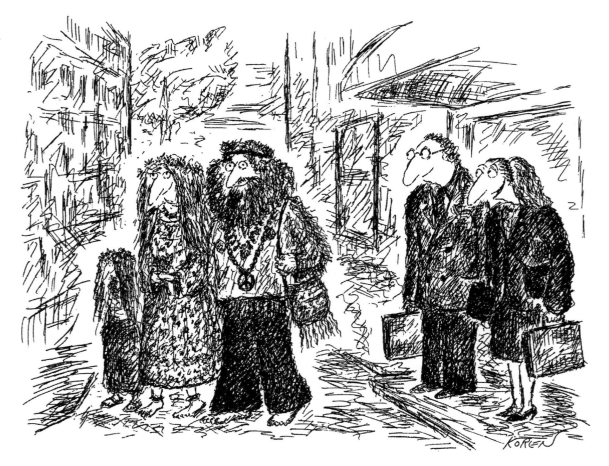

"They're museum quality!"

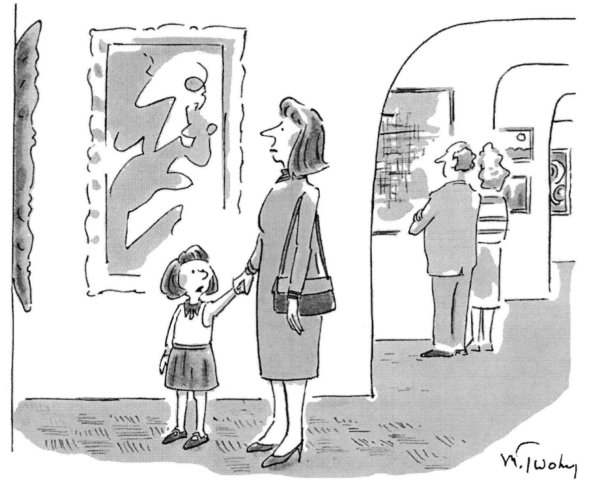

"Now can we have an eating experience?"

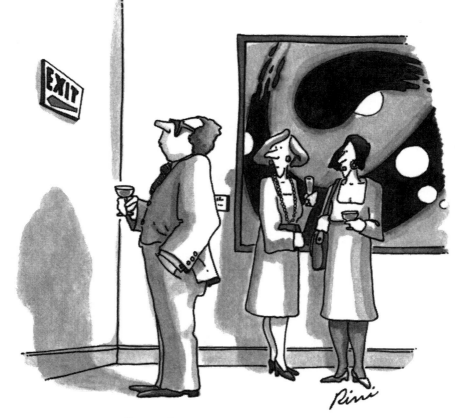

"*Roger has always been text-driven.*"

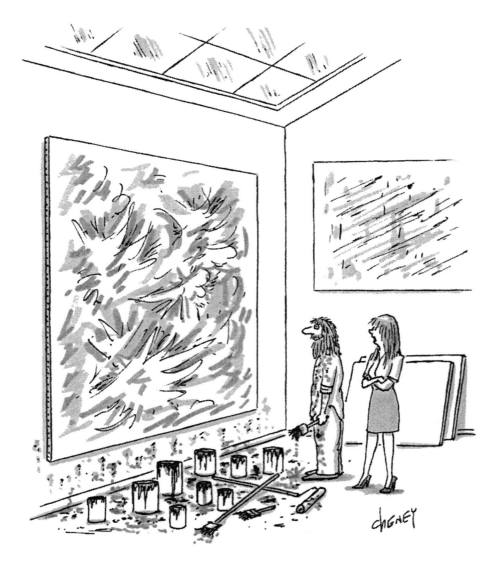

"More lithium."

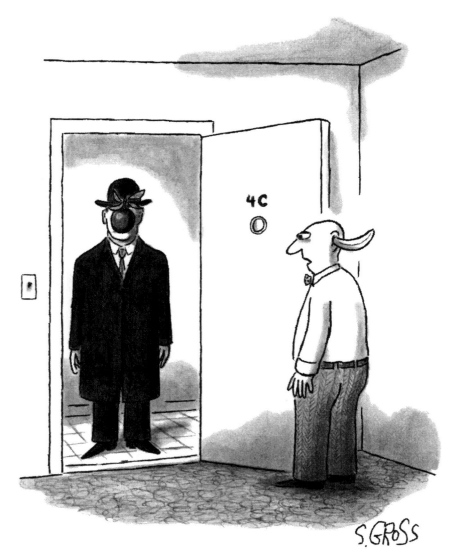

"Oh, it's you."

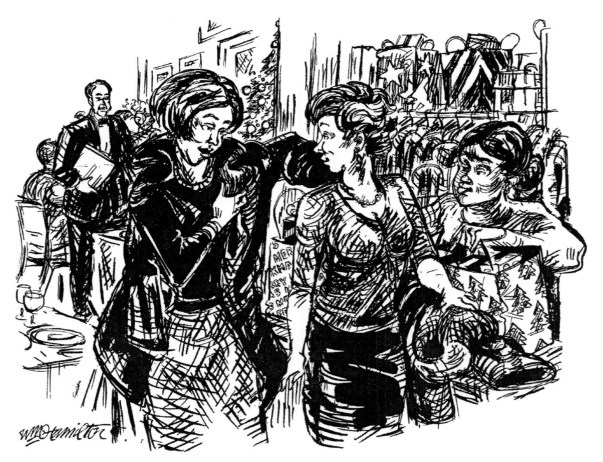

"For big, important things, it's the Met and the Modern, of course—but the Whitney is great for stocking stuffers."

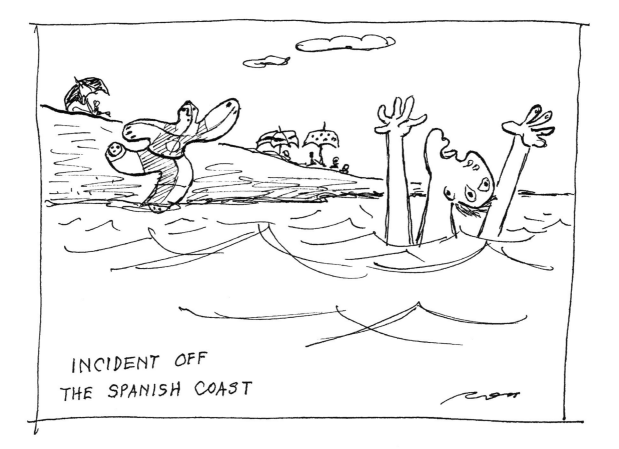

INCIDENT OFF
THE SPANISH COAST

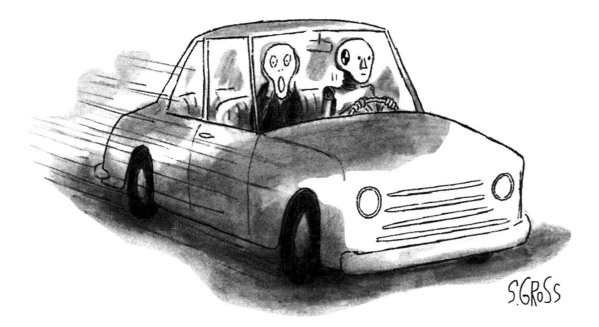

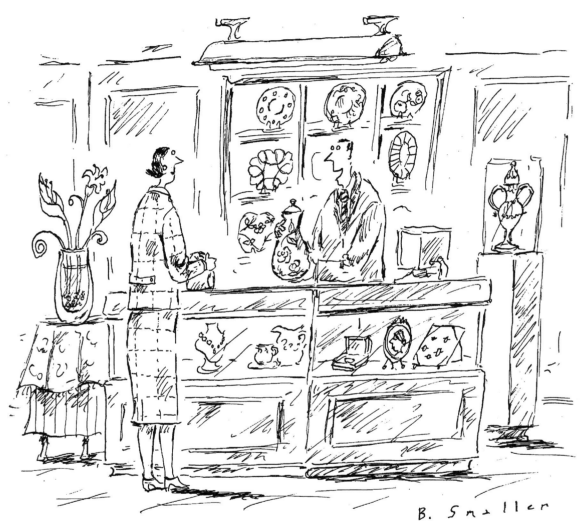

"*It's museum-store quality.*"

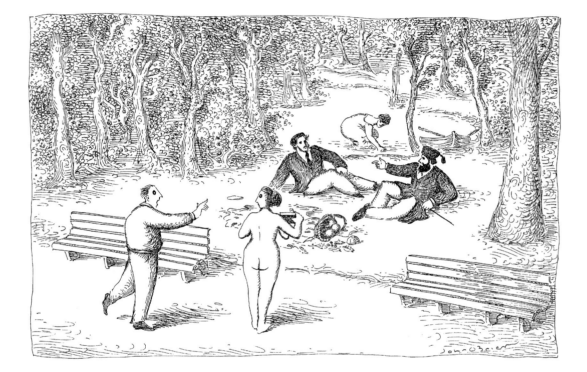

"Here! Let me get you all in!"

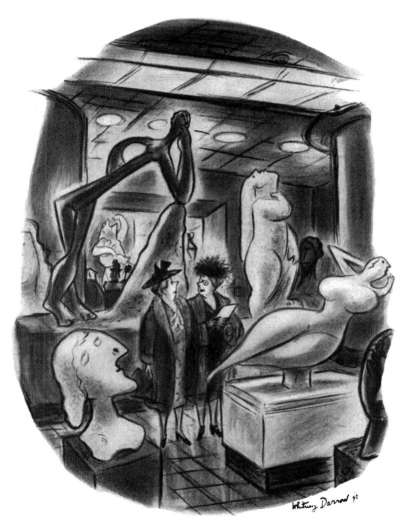

"Why doesn't he pick on his own sex for a change?"

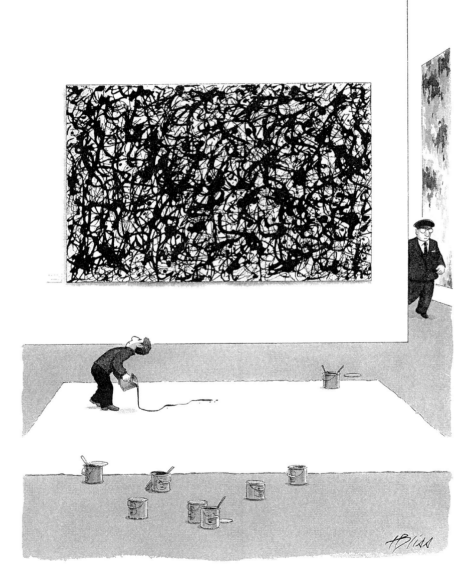

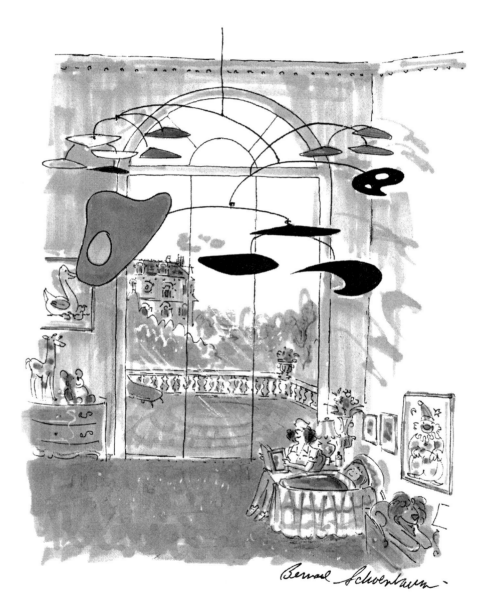

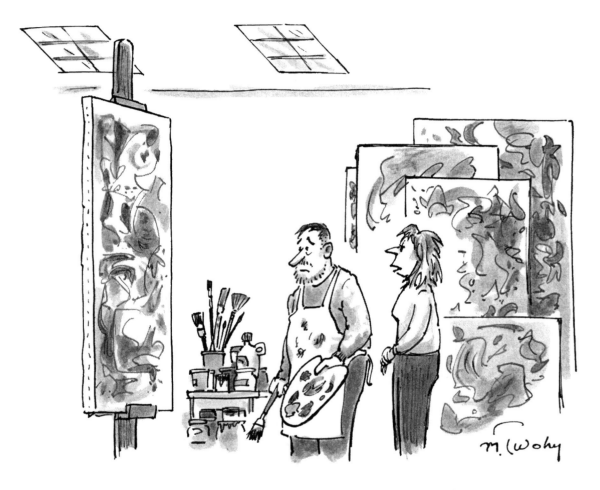

"They're no more pointless now than they ever were."

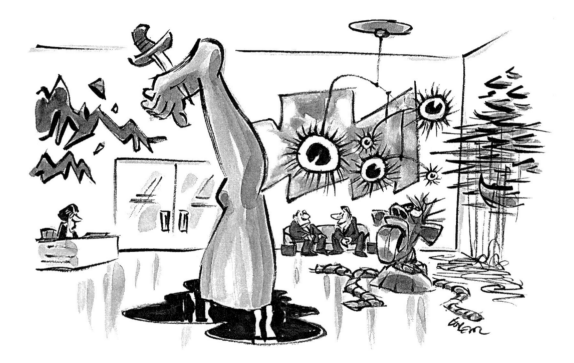

"On the other hand, their accounting procedures are impeccable."

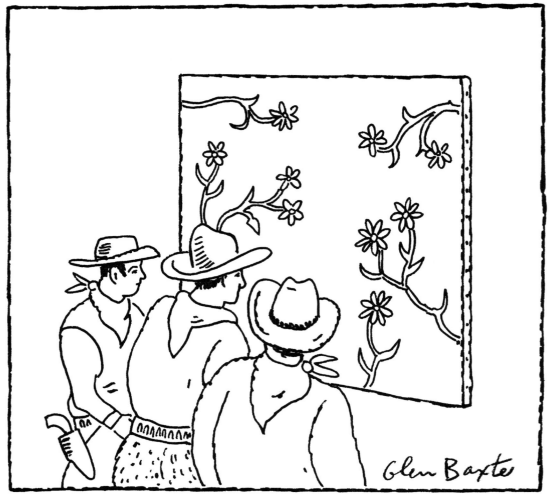

THE CRITICS SPOTTED THE BOGUS
ROTHKO ALMOST IMMEDIATELY.

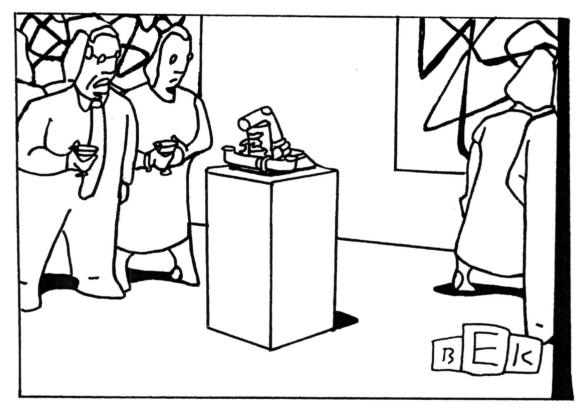

"It's found crap."

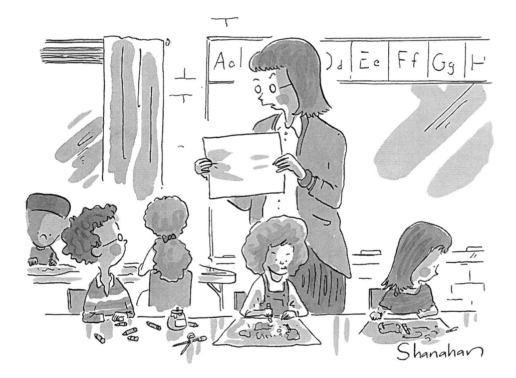

"The innocence seems forced."

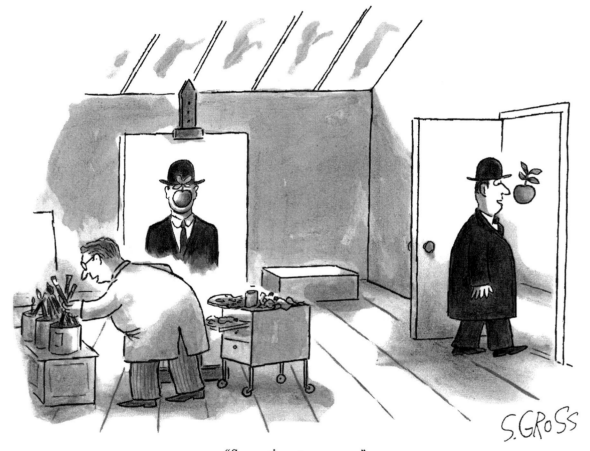

"*Same time tomorrow.*"

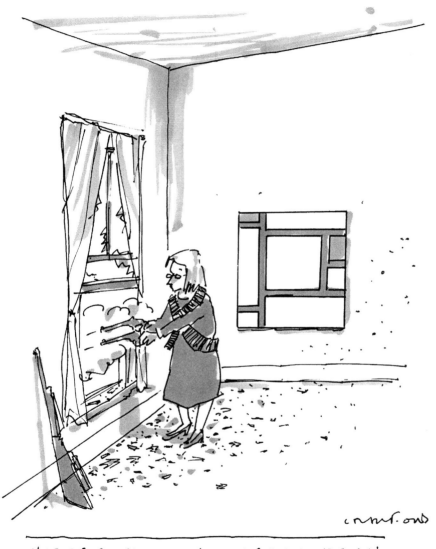

NOBODY COMES BETWEEN NANCY & HER MONDRIAN

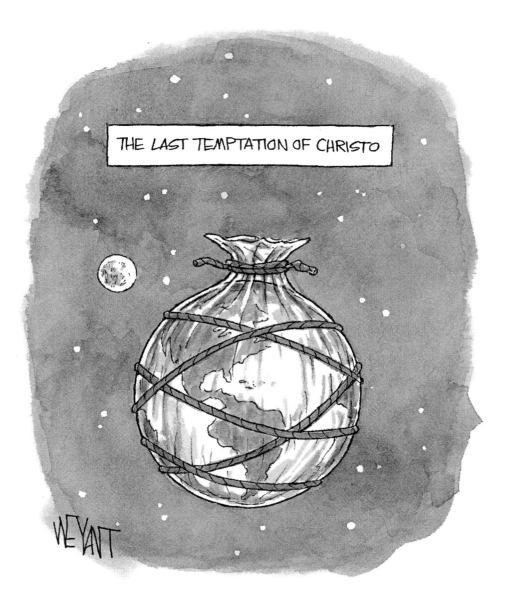

THE LAST TEMPTATION OF CHRISTO

WEYANT

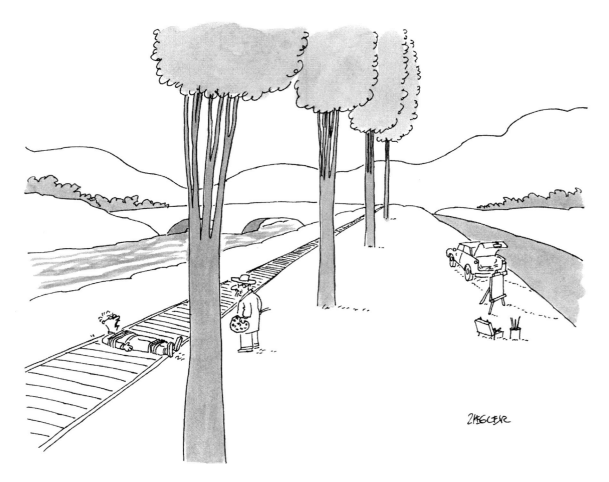

"Damn it, man, do I look like I have any yellow ochre?"

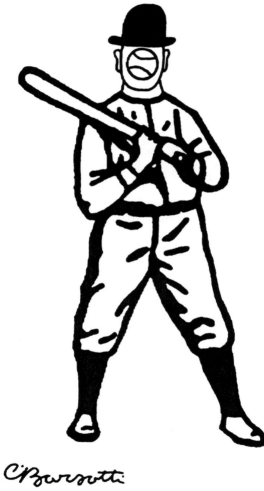

MAGRITTE TAKES ONE HIGH AND INSIDE

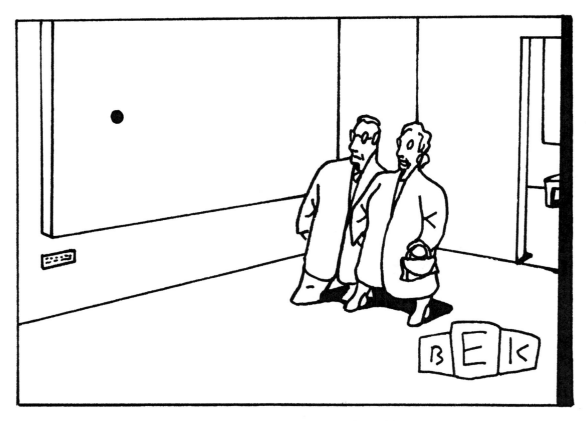

"*Where does he get all his ideas?*"

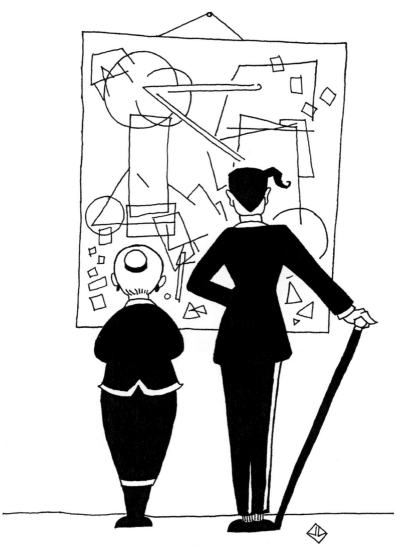

"How do you know when you're done appreciating?"

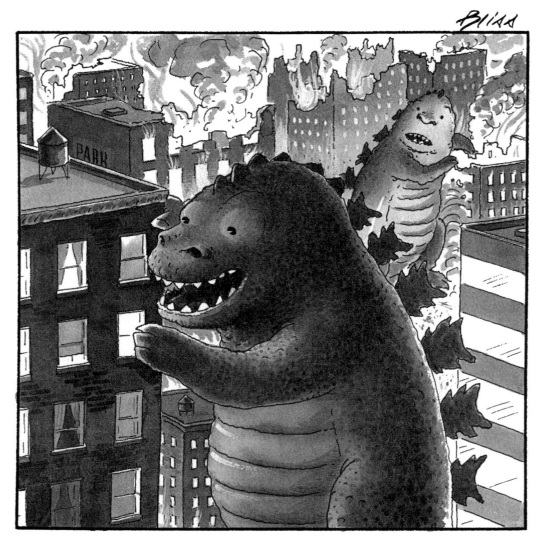

"Lou, c'm'ere—you gotta check out this guy's Degas!"

INDEX OF ARTISTS

Front cover: Mike Twohy
Front jacket flap: Mike Twohy
Back cover: Charles Saxon
Back jacket flap: Arnie Levin